1983

THE Easter STORY
IN STAINED GLASS

Photographs by Sonia Halliday
and Laura Lushington

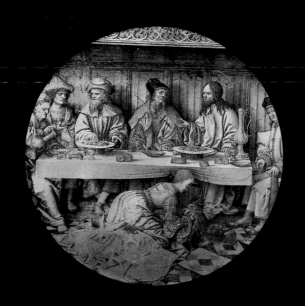

William B. Eerdmans Publishing Company
Grand Rapids, Michigan

For three remarkable years
Jesus Christ declared God's message
to his people, healing the sick.
His life shone like a light
in the darkness. Then he travelled
to Jerusalem for the last time
– the beginning of a week that
was to change the world . . .

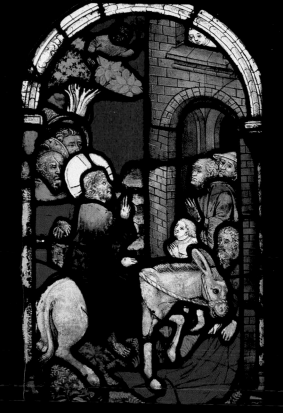

Jesus' entry into Jerusalem, by Hans Acker, fifteenth century, at Ulm Cathedral, Germany.

The great crowd that had come for the Feast heard that Jesus was on his way to Jerusalem. They took palm branches and went out to meet him, shouting,
'Hosanna!'
'Blessed is he who comes in the name of the Lord!'
'Blessed is the King of Israel!'

Jesus found a young donkey and sat upon it, as it is written,
'Do not be afraid, O Daughter of Zion;
see, your king is coming,
seated on a donkey's colt.'

At first his disciples did not understand all this. Only after Jesus was glorified did they realise that these things had been written about him.

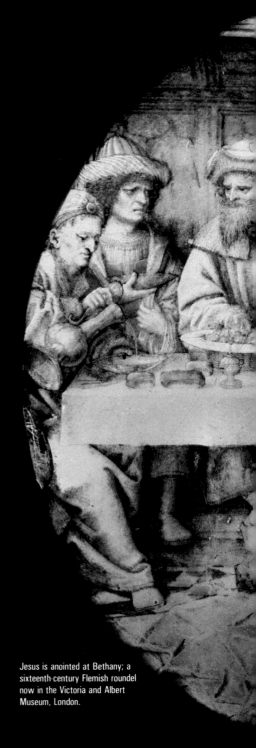

J esus arrived at Bethany, where Lazarus lived, whom Jesus had raised from the dead. Here a dinner was given in Jesus' honour. Martha served, while Lazarus was among those reclining at the table with him. Then Mary took about a pint of pure nard, an expensive perfume; she poured it on Jesus' feet and wiped his feet with her hair. And the house was filled with the fragrance of the perfume.

But one of his disciples, Judas Iscariot, who was later to betray him, objected, 'Why wasn't this perfume sold and the money given to the poor? It was worth a year's wages.'. . .

'Leave her alone,' Jesus replied. 'It was meant that she should save this perfume for the day of my burial.'

JOHN 12:1 – 5,7

Jesus is anointed at Bethany; a sixteenth-century Flemish roundel now in the Victoria and Albert Museum, London.

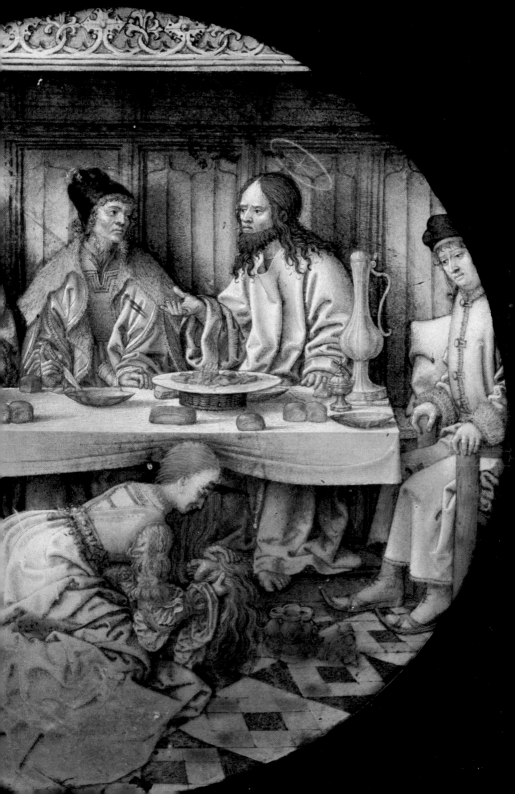

T hen came the day of Unleavened Bread on which the Passover lamb had to be sacrificed . . . When the hour came, Jesus and his apostles reclined at the table. And he said to them, 'I have eagerly desired to eat this Passover with you before I suffer. For I tell you, I will not eat it again until it finds fulfilment in the kingdom of God.'

After taking the cup, he gave thanks and said, 'Take this and divide it among you. For I tell you, I will not drink again of the fruit of the vine until the kingdom of God comes.'

And he took bread, gave thanks and broke it, and gave it to them, saying, 'This is my body given for you; do this in remembrance of me.'

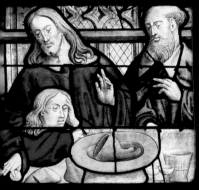
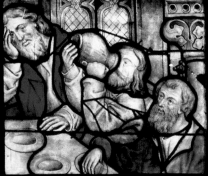

In the same way, after the supper he took the cup, saying, 'This cup is the new covenant in my blood, which is poured out for you. But the hand of him who is going to betray me is with mine on the table. The Son of Man will go as it has been decreed, but woe to that man who betrays him.'

LUKE 22:7,14 – 22

The last supper; a fifteenth-century window in the Church of St Maria, Wiesenkirche, Soest, Germany.

They went to a place called Gethsemane, and Jesus said to his disciples, 'Sit here while I pray.' He took Peter, James and John along with him, and he began to be deeply distressed and troubled. 'My soul is overwhelmed with sorrow to the point of death,' he said to them. 'Stay here and keep watch.'

Going a little farther, he fell to the ground and prayed that if possible the hour might pass from him. 'Abba, Father,' he said, 'everything is possible for you. Take this cup from me. Yet not what I will, but what you will.'

Then he returned to his disciples and found them sleeping. 'Simon,' he said to Peter, 'are you asleep? Could you not keep watch for one hour? Watch and pray so that you will not fall into temptation. The spirit is willing, but the body is weak.'

Once more he went away and prayed the same thing. When he came back, he again found them sleeping, because their eyes were heavy. They did not know what to say to him.

Returning the third time, he said to them, 'Are you still sleeping and resting? Enough! The hour has come. Look, the Son of Man is betrayed into the hands of sinners. Rise! Let us go! Here comes my betrayer!'

MARK 14:32 – 42

Jesus praying in Gethsemane, by Hans Acker, fifteenth century, at Ulm Cathedral, Germany.

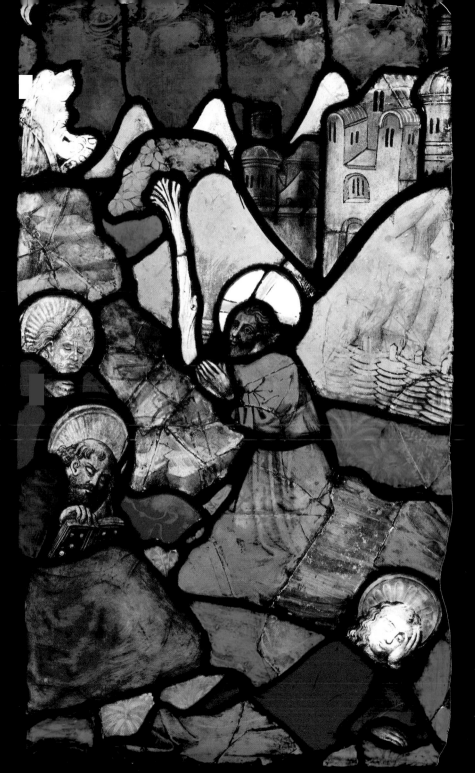

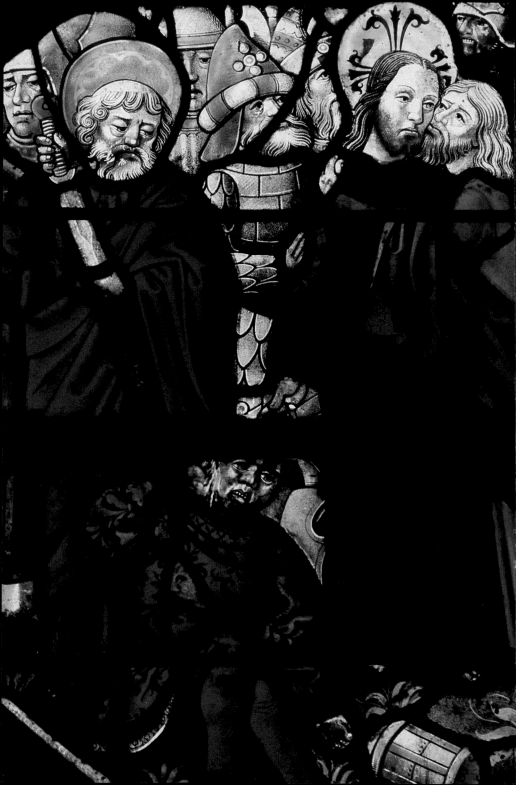

*J*ust as he was speaking, Judas, one of the Twelve, appeared. With him was a crowd armed with swords and clubs, sent from the chief priests, the teachers of the law and the elders.

Now the betrayer had arranged a signal with them: 'The one I kiss is the man; arrest him and lead him away under guard.' Going at once to Jesus, Judas said, 'Rabbi!' and kissed him. The men seized Jesus and arrested him. Then one of those standing near drew his sword and struck the servant of the high priest, cutting off his ear.

'Am I leading a rebellion,' said Jesus, 'that you have come out with swords and clubs to capture me? Every day I was with you, teaching in the temple courts, and you did not arrest me. But the Scriptures must be fulfilled.' Then everyone deserted him and fled.

MARK 14:43 – 50

Jesus is betrayed; a
fifteenth-century panel in the
Church of La Madaleine, Troyes,
France.

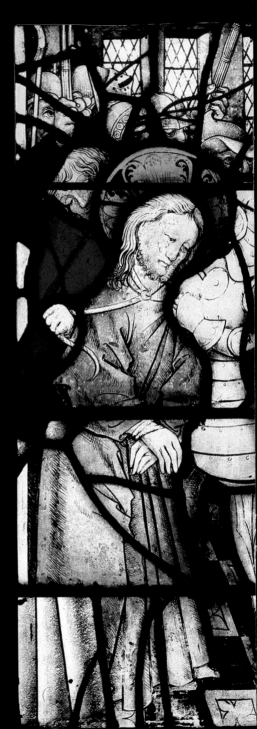

T hose who had arrested Jesus took him to Caiaphas, the high priest, where the teachers of the law and the elders had assembled . . . The chief priests and the whole Sanhedrin were looking for false evidence against Jesus so that they could put him to death. But they did not find any, though many false witnesses came forward.

Finally two came forward and declared, 'This fellow said, "I am able to destroy the temple of God and rebuild it in three days."' Then the high priest stood up and said to Jesus, 'Are you not going to answer? What is this testimony that these men are bringing against you?' But Jesus remained silent.

The high priest said to him, 'I charge you under oath by the living God: Tell us if you are the Christ, the Son of God.' 'Yes, it is as you say,' Jesus replied. 'But I say to all of you: In future you will see the Son of Man sitting at the right hand of the Mighty One and coming on the clouds of heaven.'

Then the high priest tore his clothes and said, 'He has spoken blasphemy! Why do we need any more witnesses? Look, now you have heard the blasphemy. What do you think?' 'He is worthy of death,' they answered.

MATTHEW 26:57 59–66

Jesus before Caiaphas: a fifteenth-century German panel now in St Mary's Church, Stoke d'Abernon, England.

Now Peter was sitting out in the courtyard, and a servant girl came to him. 'You also were with Jesus of Galilee,' she said. But he denied it before them all. 'I don't know what you're talking about,' he said.

Then he went out to the gateway, where another girl saw him and said to the people there, 'This fellow was with Jesus of Nazareth.' He denied it again, with an oath: 'I don't know the man!'

After a little while, those standing there went up to Peter and said, 'Surely you are one of them, for your accent gives you away.' Then he began to call down curses on himself and he swore to them, 'I don't know the man!'

Immediately a cock crowed. Then Peter remembered the word Jesus had spoken: 'Before the cock crows, you will disown me three times.' And he went outside and wept bitterly.

MATTHEW 26:69 – 75

Peter disowns Jesus;
fifteenth century from Ulm
Cathedral, Germany.

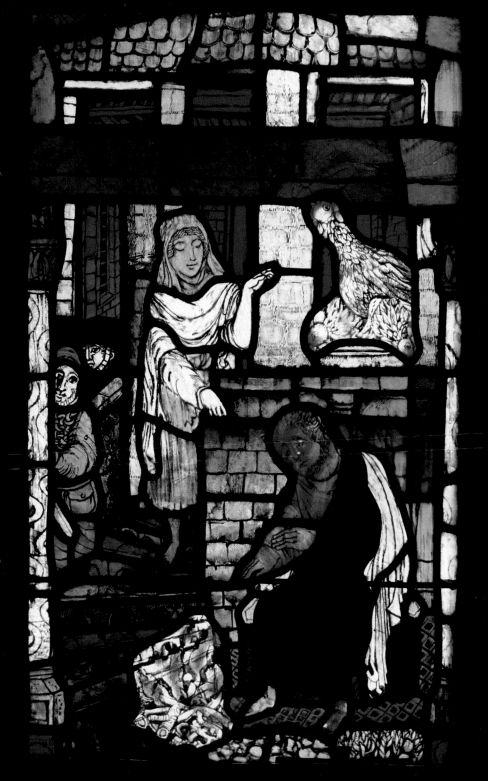

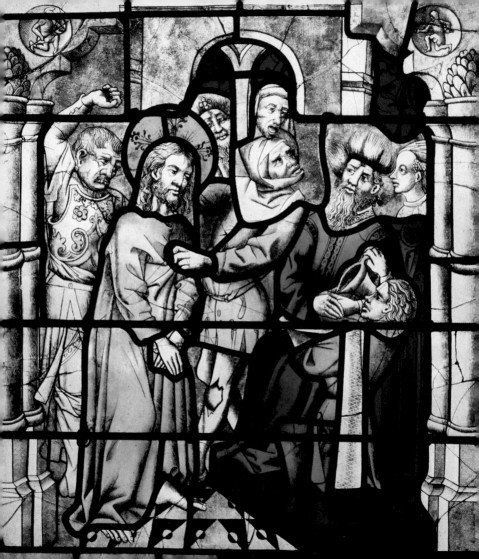

Now it was the governor's custom at the Feast to release a prisoner chosen by the crowd. At that time they had a notorious prisoner, called Barabbas. So when the crowd had gathered, Pilate asked them, 'Which one do you want me to release to you: Barabbas, or Jesus who is called Christ?' For he knew it was out of envy that they had handed Jesus over to him.

While Pilate was sitting on the judge's seat, his wife sent him this message: 'Don't have anything to do with that innocent man, for I have suffered a great deal today in a dream because of him.'

But the chief priests and the elders persuaded the crowd to ask for Barabbas and to have Jesus executed.

'Which of the two do you want me to release to you?' asked the governor.

'Barabbas,' they answered.

'What shall I do, then, with Jesus who is called Christ?' Pilate asked.

They all answered, 'Crucify him!'

'Why? What crime has he committed?' asked Pilate.

But they shouted all the louder, 'Crucify him!'

When Pilate saw that he was getting nowhere, but that instead an uproar was starting, he took water and washed his hands in front of the crowd. 'I am innocent of this man's blood,' he said. 'It is your responsibility!'

MATTHEW 27:15–24

Pilate washes his hands;
fifteenth century from Cologne
Cathedral, Germany.

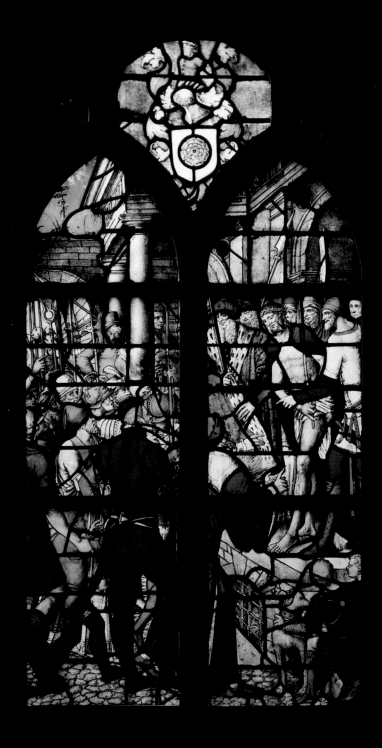

The soldiers led Jesus away into the palace (that is, the Praetorium) and called together the whole company of soldiers. They put a purple robe on him, then wove a crown of thorns and set it on him. And they began to call out to him, 'Hail, King of the Jews!' Again and again they struck him on the head with a staff and spat on him. Falling on their knees, they worshipped him. And when they had mocked him, they took off the purple robe and put his own clothes on him. Then they led him out to crucify him.

MARK 15:16 – 20

The soldiers mock Jesus;
AD 1556, in the Chapel of
St John, Gouda, Holland.

Two other men, both criminals, were also led out with him to be executed. When they came to the place called The Skull, there they crucified him, along with the criminals – one on his right, the other on his left. Jesus said, 'Father, forgive them, for they do not know what they are doing.' And they divided up his clothes by casting lots.

The people stood watching, and the rulers even sneered at him. They said, 'He saved others; let him save himself if he is the Christ of God, the Chosen One.'

The soldiers also came up and mocked him. They offered him wine vinegar and said, 'If you are the king of the Jews, save yourself.' There was a written notice above him, which read: THIS IS THE KING OF THE JEWS.

One of the criminals who hung there hurled insults at him: 'Aren't you the Christ? Save yourself and us!'
But the other criminal rebuked him. 'Don't you fear God,' he said, 'since you are under the same sentence? We are punished justly, for we are getting what our deeds deserve. But this man has done nothing wrong.' Then he said, 'Jesus, remember me when you come into your kingdom.'
Jesus answered him, 'I tell you the truth, today you will be with me in paradise.'

LUKE 23:32 – 43

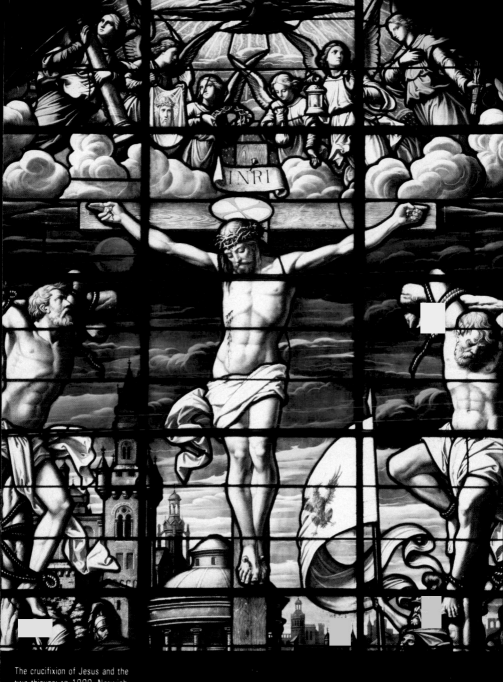

The crucifixion of Jesus and the two thieves: AD 1900, Norwich Cathedral, England.

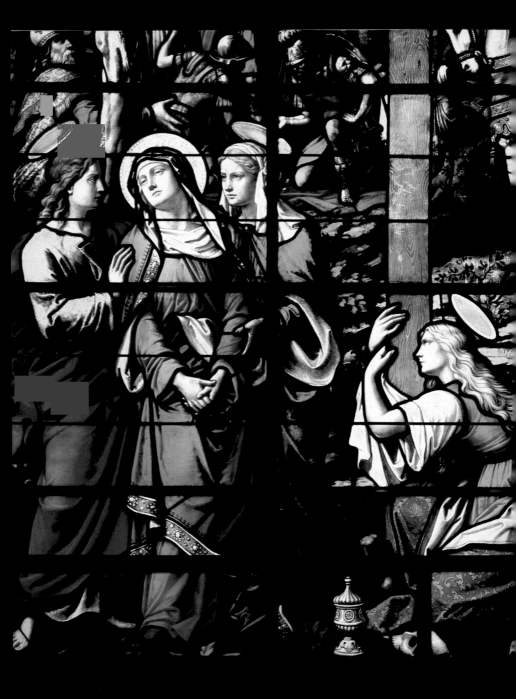

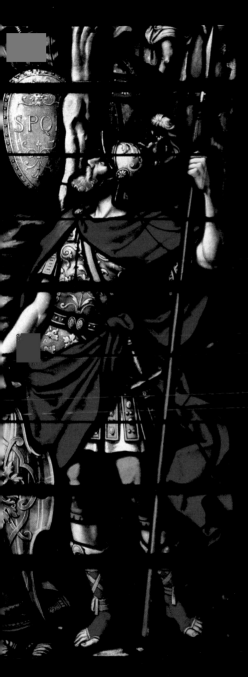

It was now about the sixth hour, and darkness came over the whole land until the ninth hour, for the sun stopped shining. And the curtain of the temple was torn in two. Jesus called out with a loud voice, 'Father, into your hands I commit my spirit.' When he had said this, he breathed his last.

The centurion, seeing what had happened, praised God and said, 'Surely this was a righteous man.'

LUKE 23:44 – 47

The centurion at the cross; a detail from the 'crucifixion' window, Norwich Cathedral, England.

As evening approached, there came a rich man from Arimathea, named Joseph, who had himself become a disciple of Jesus. Going to Pilate, he asked for Jesus' body, and Pilate ordered that it be given to him. Joseph took the body, wrapped it in a clean linen cloth, and placed it in his own new tomb that he had cut out of the rock. He rolled a big stone in front of the entrance and went away.

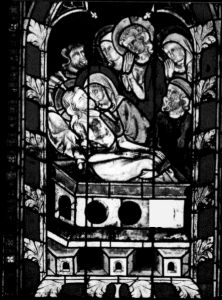

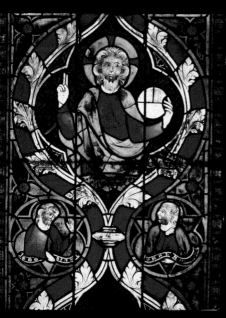

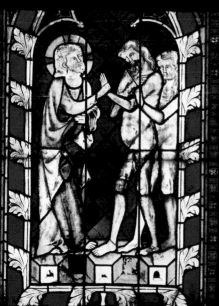

The next day, the one after Preparation Day, the chief priests and the Pharisees went to Pilate. 'Sir,' they said, 'we remember that while he was still alive that deceiver said, "After three days I will rise again." So give the order for the tomb to be made secure until the third day. Otherwise, his disciples may come and steal the body and tell the people that he has been raised from the dead. This last deception will be worse than the first.'

'Take a guard,' Pilate answered. 'Go, make the tomb as secure as you know how.' So they went and made the tomb secure by putting a seal on the stone and posting the guard.

MATTHEW 27:57 – 60, 62 – 66

The burial of Jesus;
fourteenth century from
Strasbourg Cathedral, France.

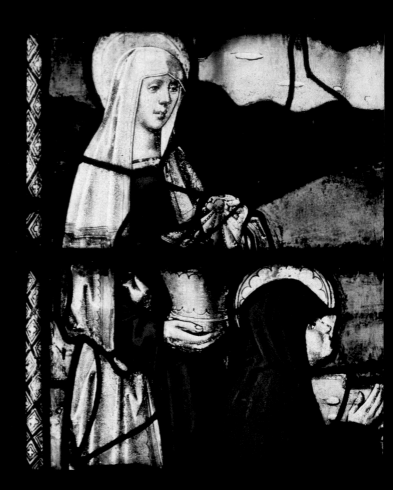

Early on the first day of the week, while it was still dark, Mary of Magdala went to the tomb and saw that the stone had been removed from the entrance . . .

Mary stood outside the tomb crying. As she wept, she bent over to look into the tomb and saw two angels in white, seated where Jesus' body had been, one at the head and the other at the foot. They asked her, 'Woman, why are you crying?'

'They have taken my Lord away,' she said, 'and I don't know where they have put him.'

At this, she turned around and saw Jesus standing there, but she did not realise that it was Jesus.

'Woman,' he said, 'why are you crying? Who is it you are looking for?'

Thinking he was the gardener, she said, 'Sir, if you have carried him away, tell me where you have put him, and I will get him.'

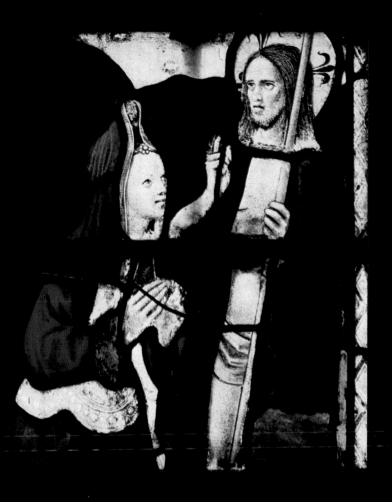

Jesus said to her, 'Mary.'
She turned towards him and cried out
in Aramaic, 'Rabboni!' (which means
Teacher).
Jesus said, 'Do not hold on to me, for I
have not yet returned to the Father. Go
instead to my brothers and tell them, "I
am returning to my Father and your
Father, to my God and your God." '

JOHN 20:1, 11 – 17

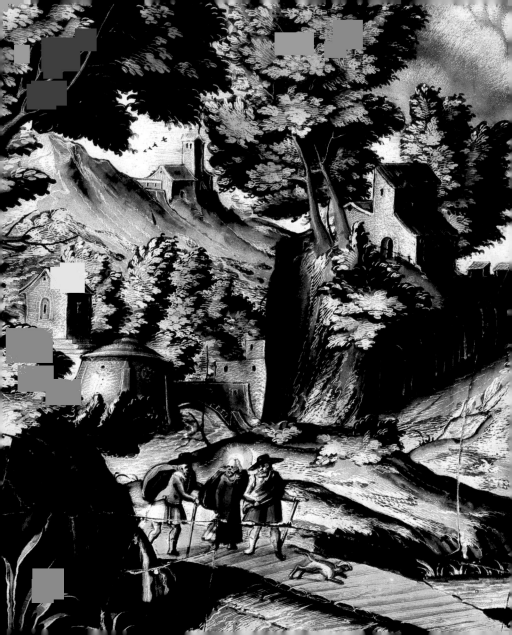

Now that same day two of them were going to a village called Emmaus, about seven miles from Jerusalem. They were talking with each other about everything that had happened. As they talked and discussed these things with each other, Jesus himself came up and walked along with them; but they were kept from recognising him. He asked them, 'What are you discussing together as you walk along?' They stood still, their faces downcast. One of them, named Cleopas, asked him, 'Are you the only one living in Jerusalem who doesn't know the things that have happened there in these days?' 'What things?' he asked. 'About Jesus of Nazareth,' they replied. 'He was a prophet, powerful in word and deed before God and all the people. The chief priests and our rulers handed him over to be sentenced to death, and they crucified him; but we had hoped that he was the one who was going to redeem Israel. And what is more, it is the third day since all this took place.'

He said to them, 'How foolish you are, and how slow of heart to believe all that the prophets have spoken! Did not the Christ have to suffer these things and then enter his glory?' And beginning with Moses and all the Prophets, he explained to them what was said in all the Scriptures concerning himself.

LUKE 24:13–21,25–27

The road to Emmaus; a Swiss panel by Heinrich Nuscheler of Zurich, now in the Darmstadt Museum, Germany.

On the evening of that first day of the week, when the disciples were together, with the doors locked for fear of the Jews, Jesus came and stood among them and said, 'Peace be with you!' After he said this, he showed them his hands and side. The disciples were overjoyed when they saw the Lord.

Now Thomas (called Didymus), one of the Twelve, was not with the disciples when Jesus came. When the other disciples told him that they had seen the Lord, he declared, 'Unless I see the nail marks in his hands and put my finger where the nails were, and put my hand into his side, I will not believe it.'

A week later his disciples were in the house again, and Thomas was with them. Though the doors were locked, Jesus came and stood among them, and said, 'Peace be with you!' Then he said to Thomas, 'Put your finger here; see my hands. Reach out your hand and put it into my side. Stop doubting and believe.'
Thomas answered, 'My Lord and my God!'
Then Jesus told him, 'Because you have seen me, you have believed; blessed are those who have not seen and yet have believed.'

JOHN 20:19–20, 24–29

Jesus speaks to Thomas; sixteenth century, Fairford, England.

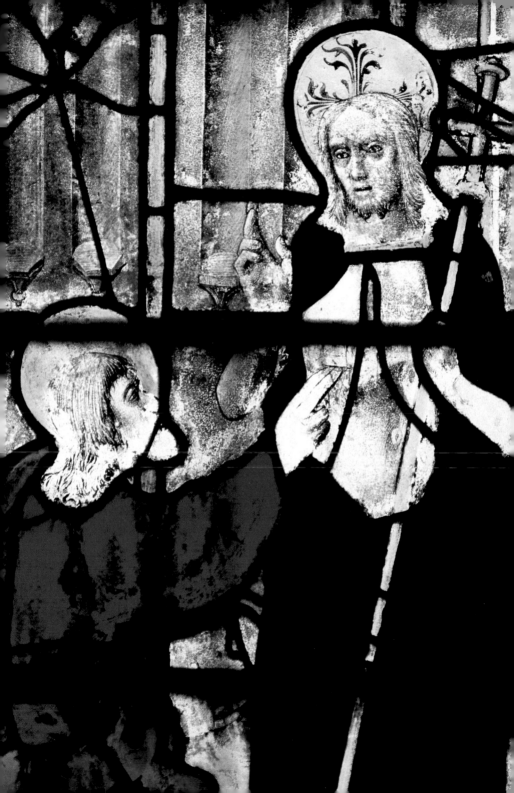

First published 1982 by Lion Publishing

First American edition published 1982 through
special arrangements with Lion by Wm. B. Eerdmans
Publishing Co., Grand Rapids, Michigan 49503.
ISBN 0-8028-3538-4

Copyright © 1982 Lion Publishing
First edition 1982
Photographs copyright © 1982 Sonia Halliday
Photographs; all photographs were taken on Pentax
6 × 7 equipment
Scripture quotations from the Holy Bible, New
International Version: copyright © New York
International Bible Society, 1978

Printed in Hong Kong by Mandarin Offset
International (H.K.) Limited